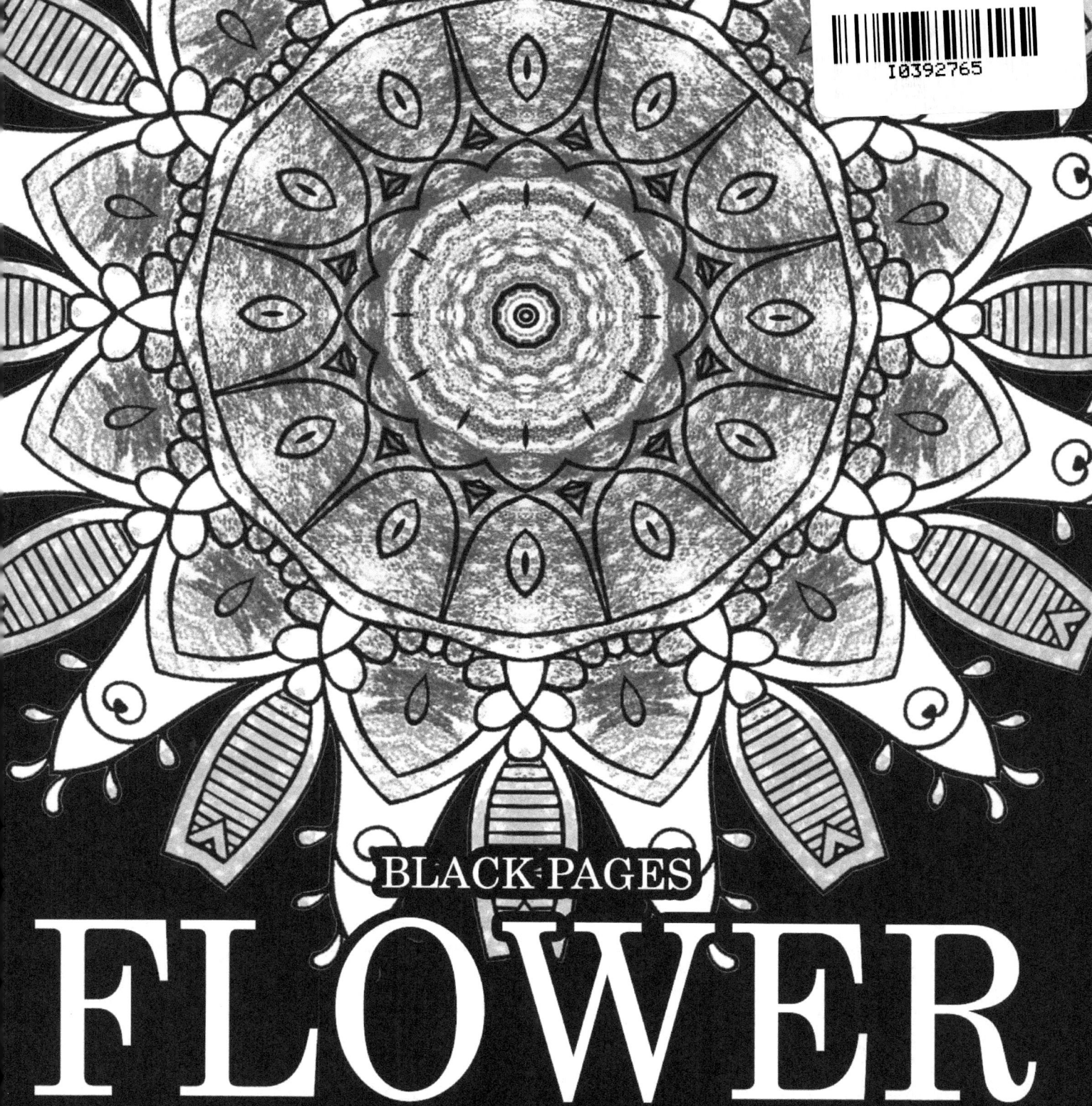

BLACK PAGES
FLOWER
MANDALAS AT MIDNIGHT

Adult Coloring Book Designs
Relaxation Stress Relief & Art Color Therapy

COLOR TEST PAGE

COLOR TEST PAGE

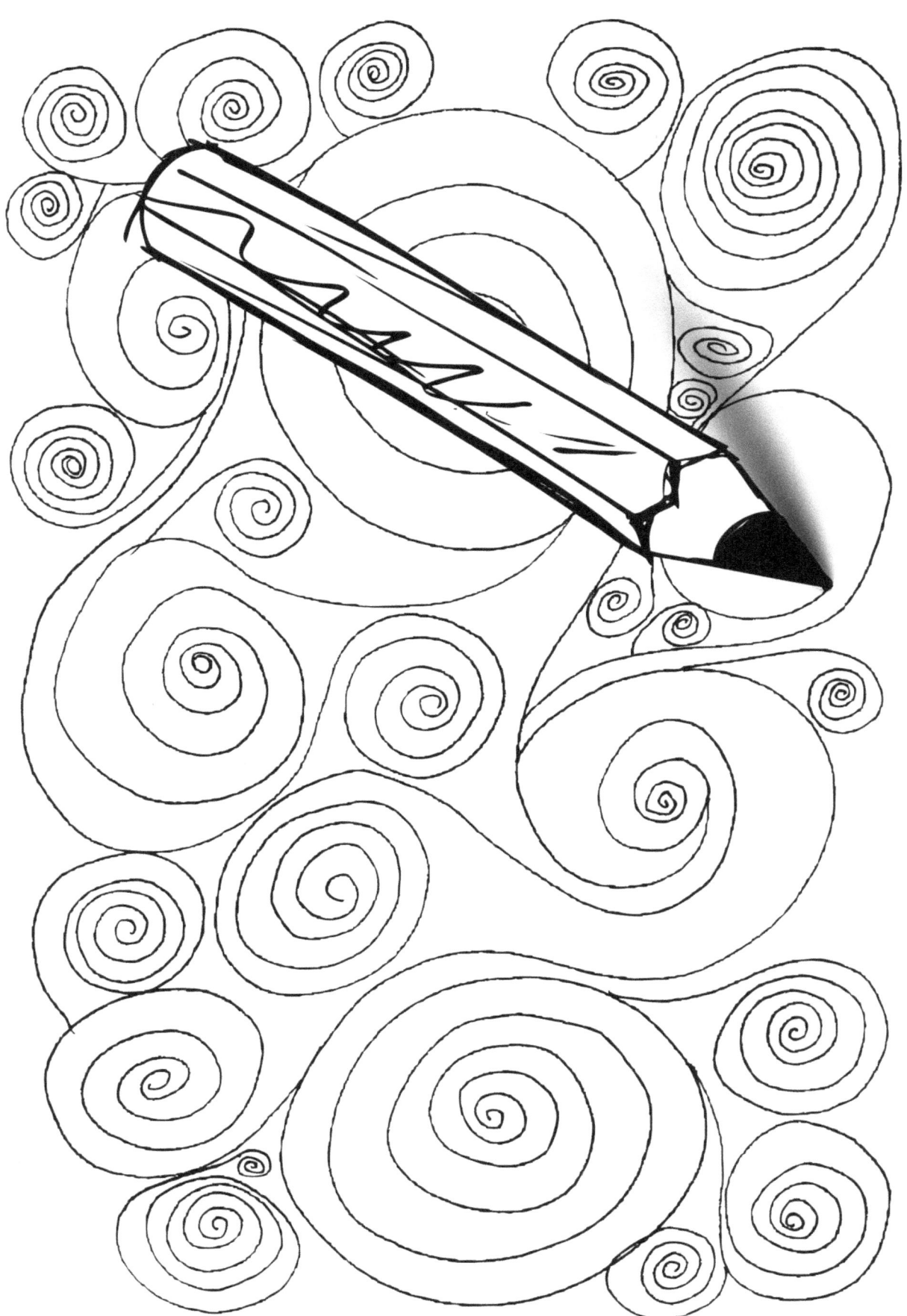

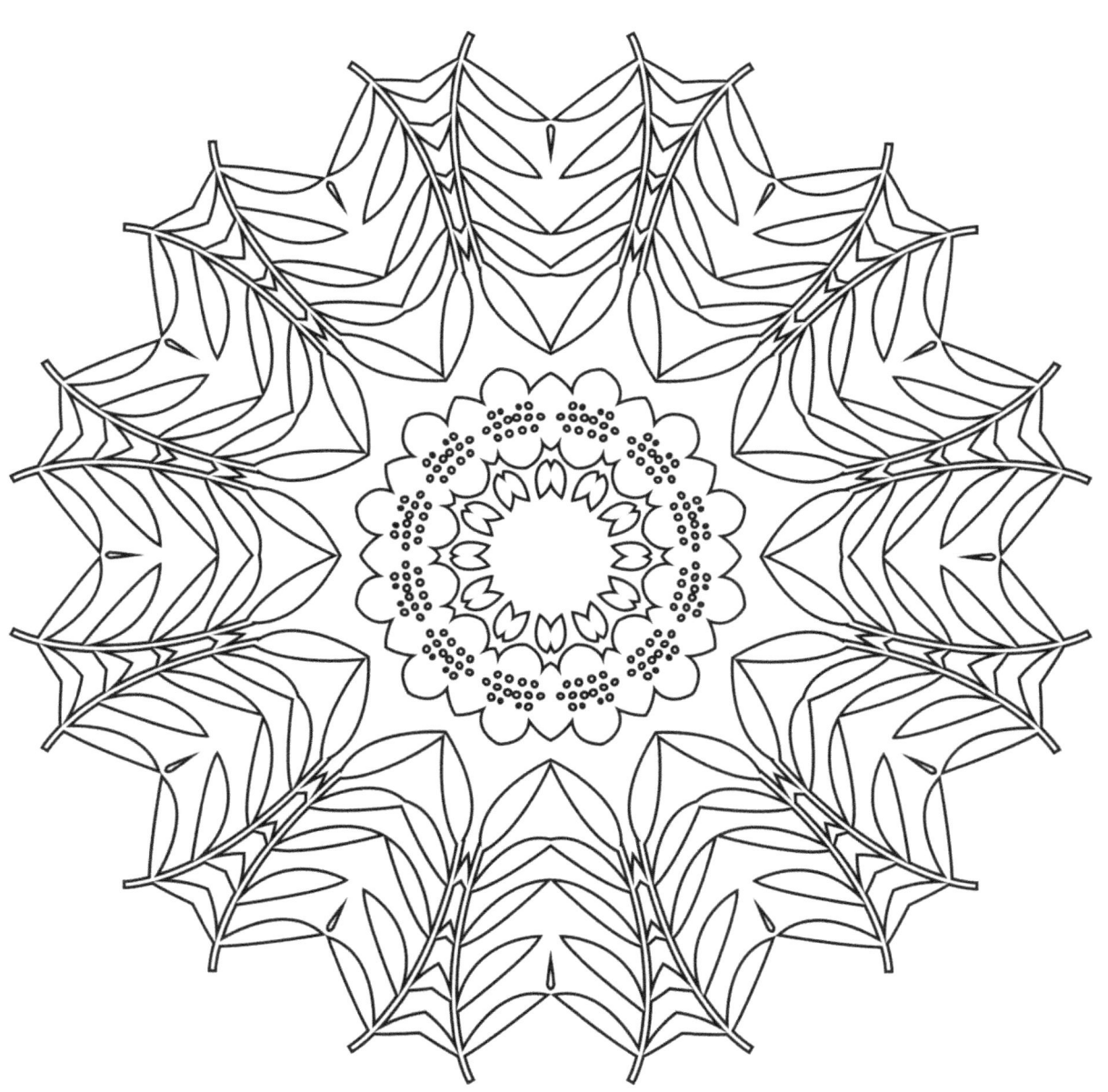

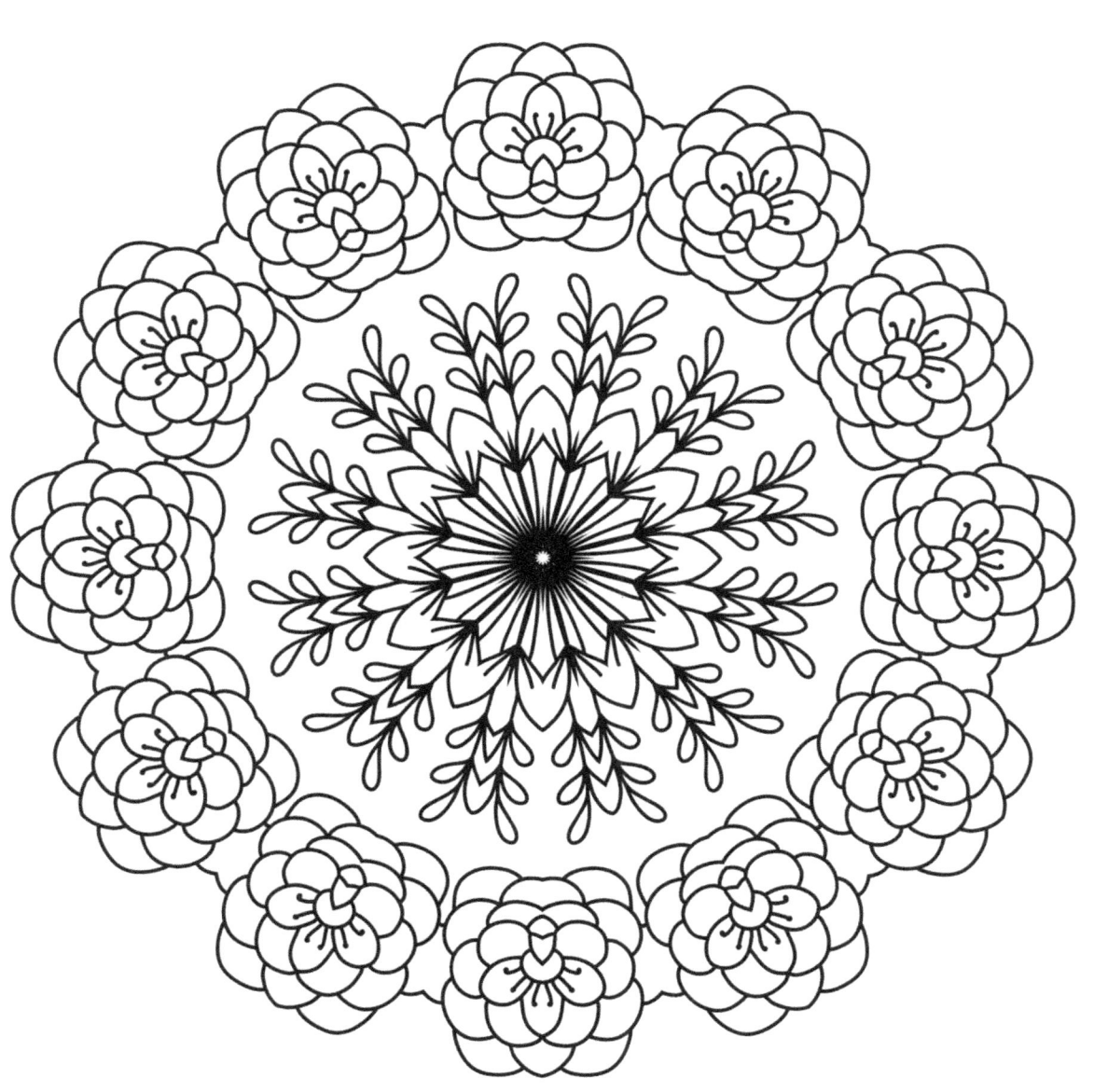

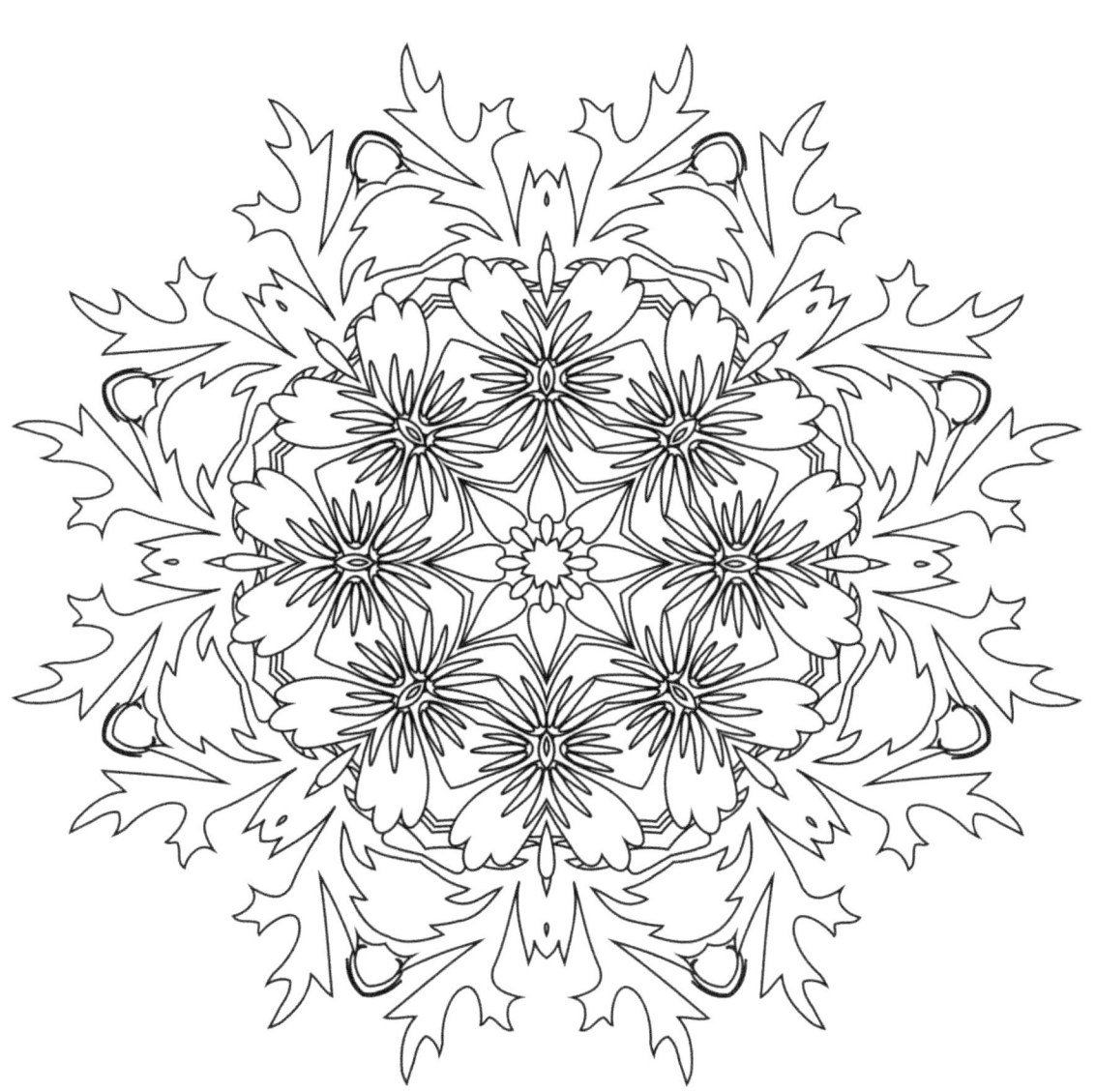

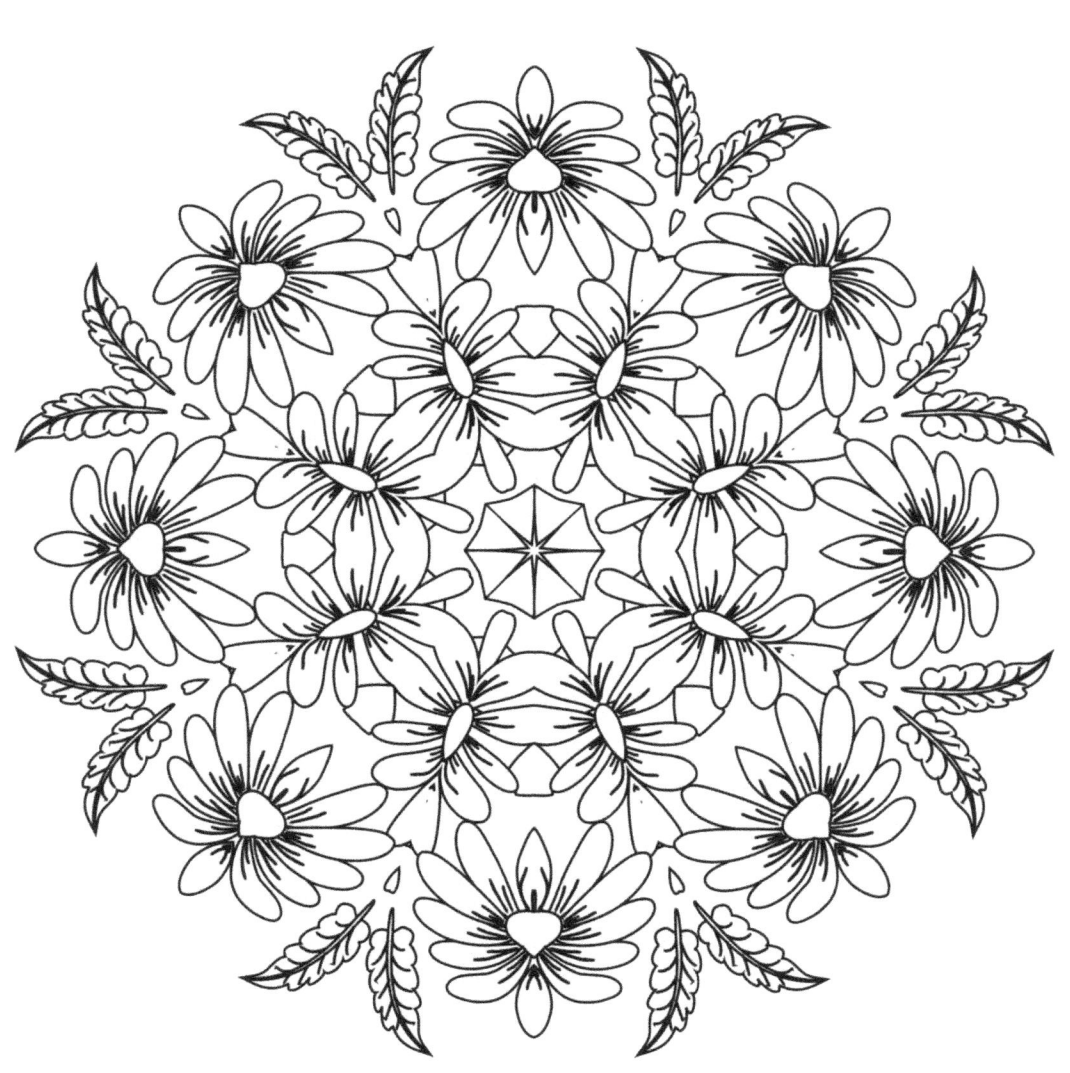

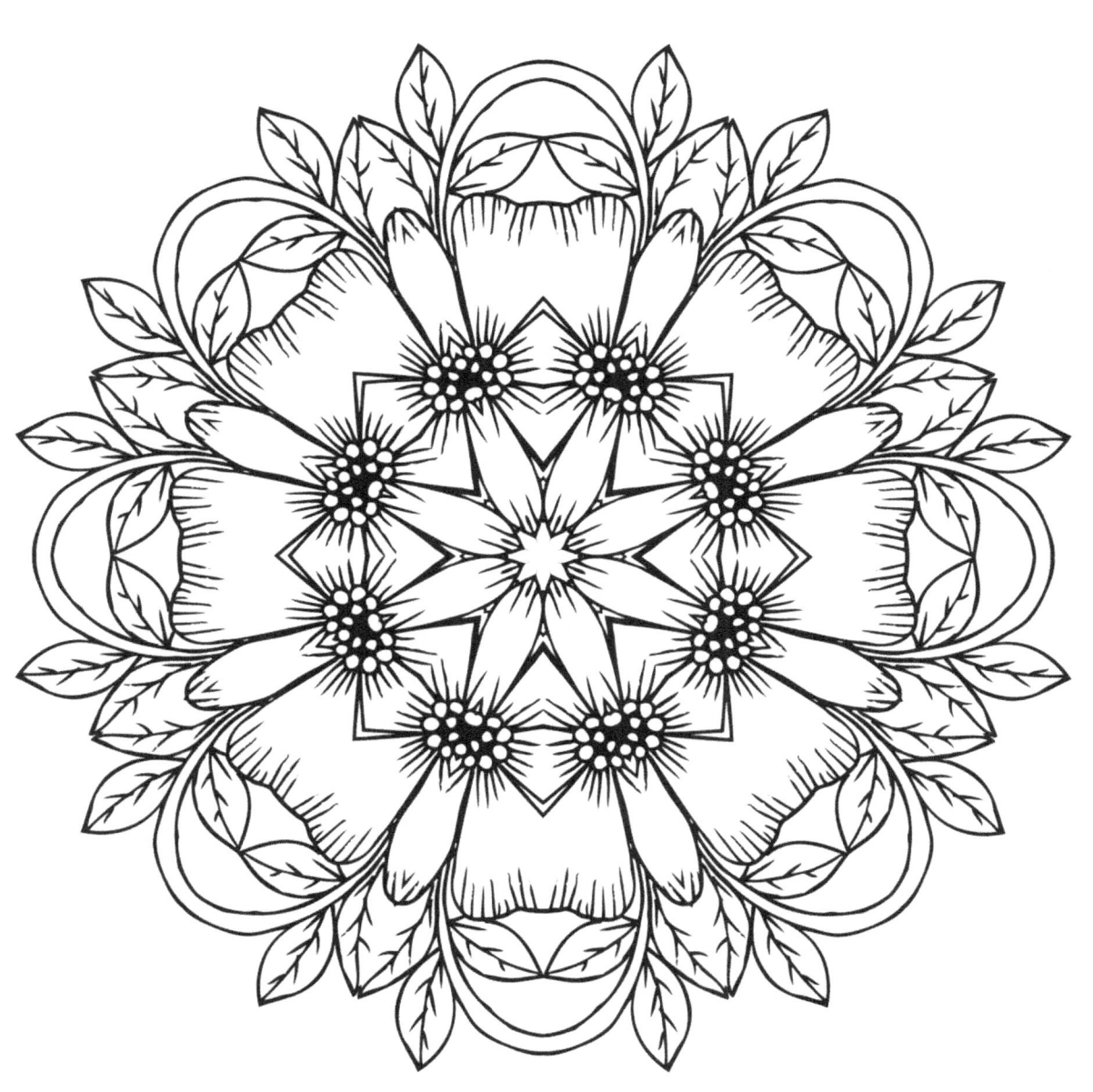

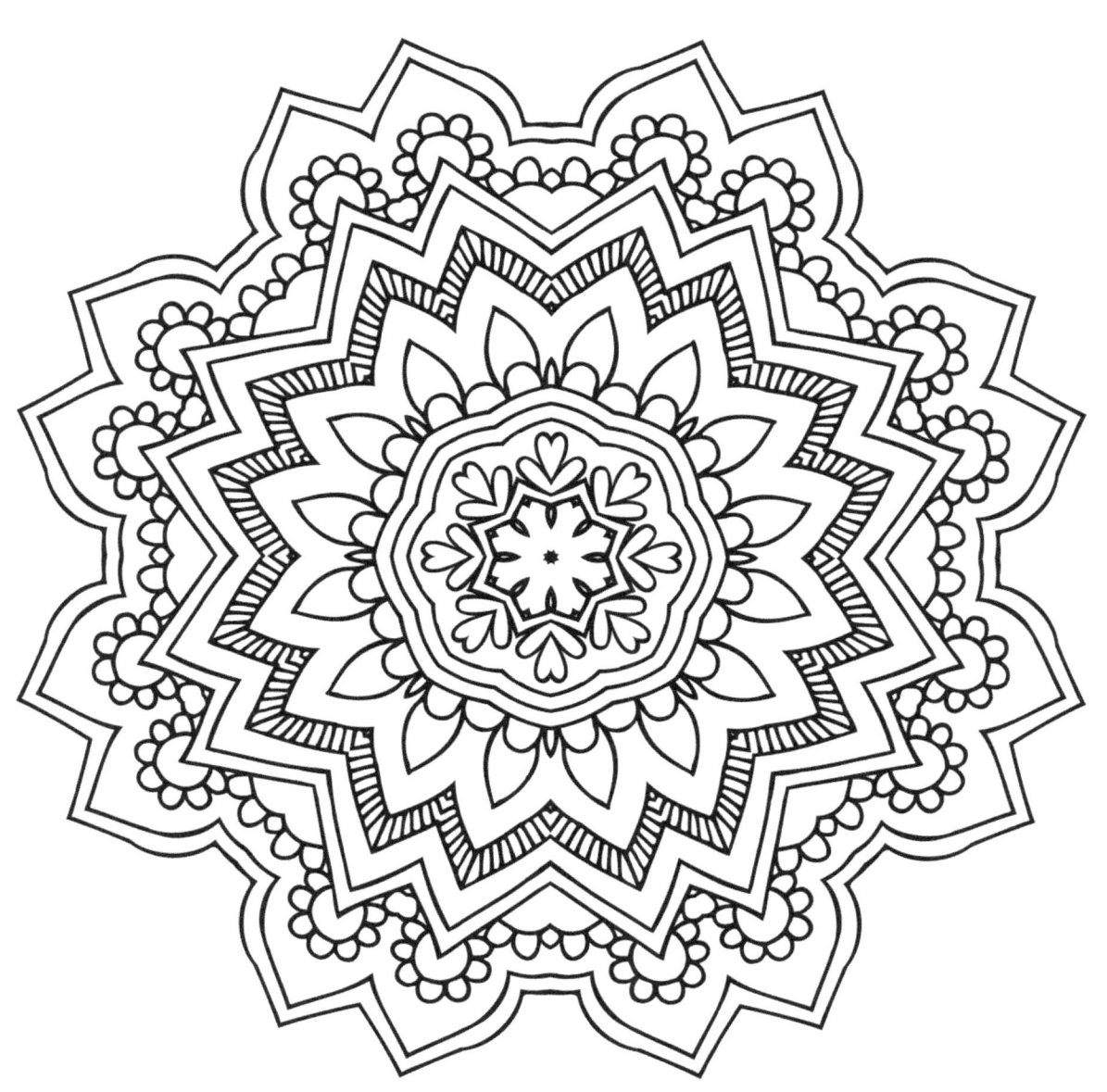

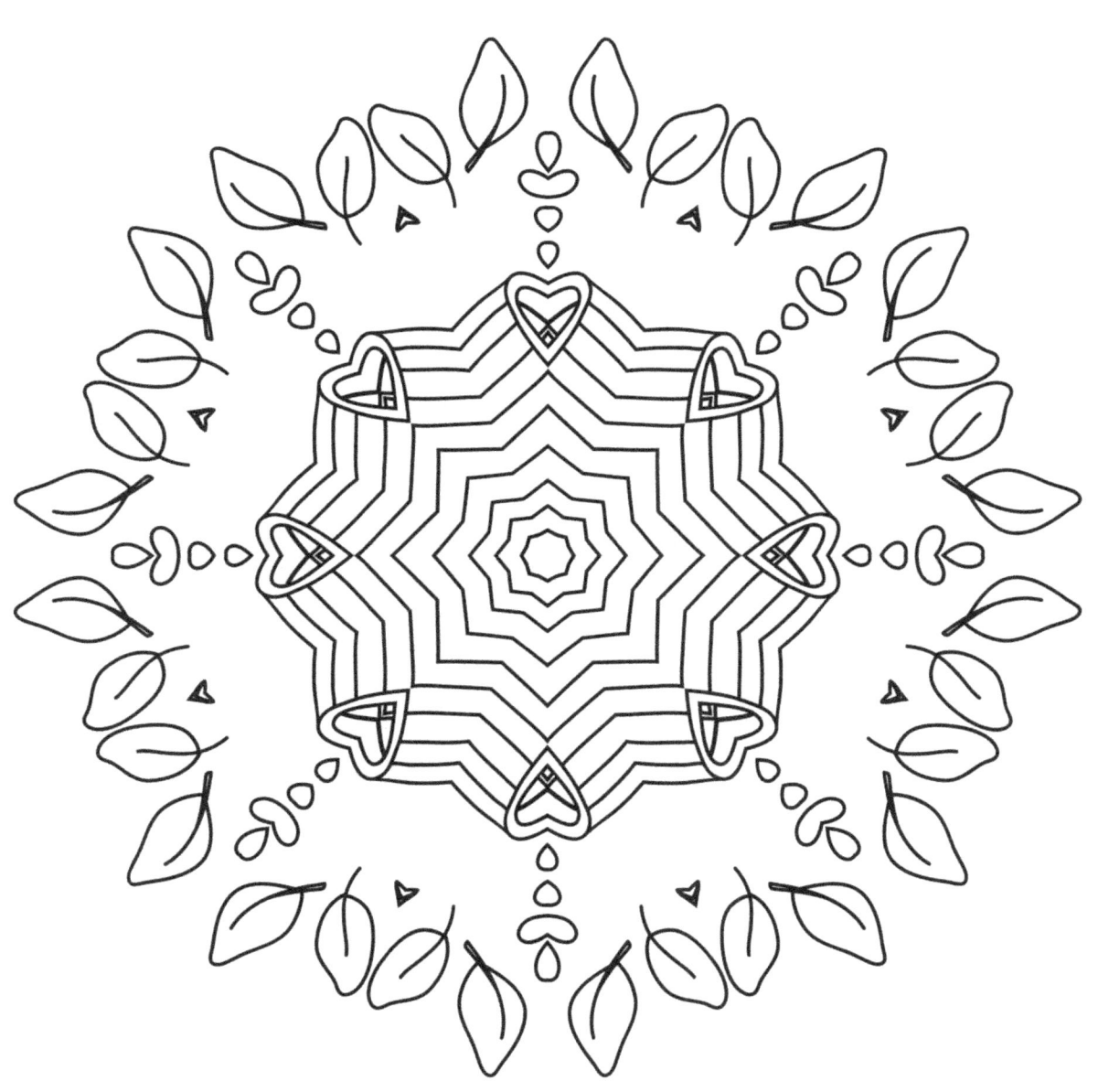

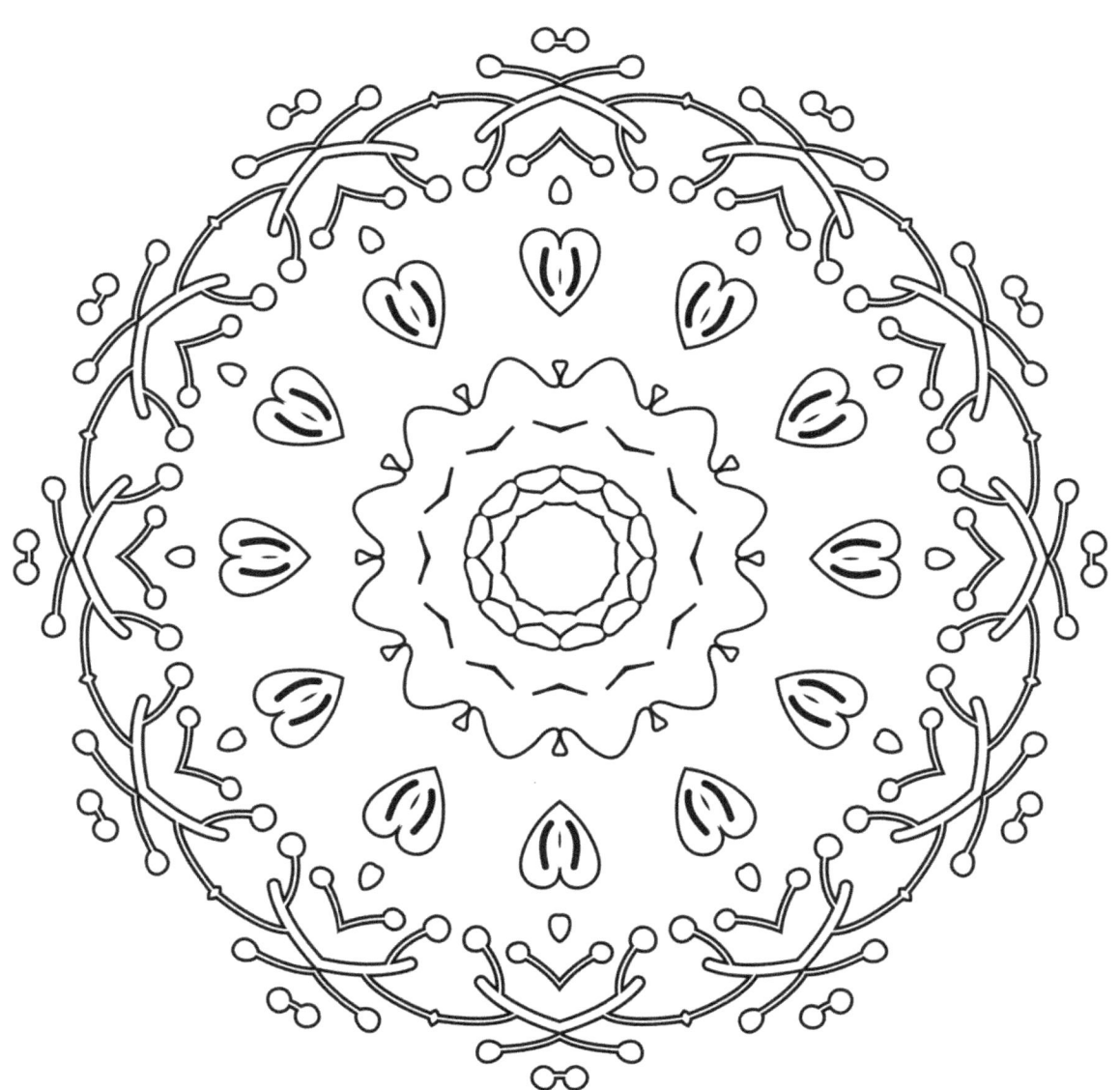

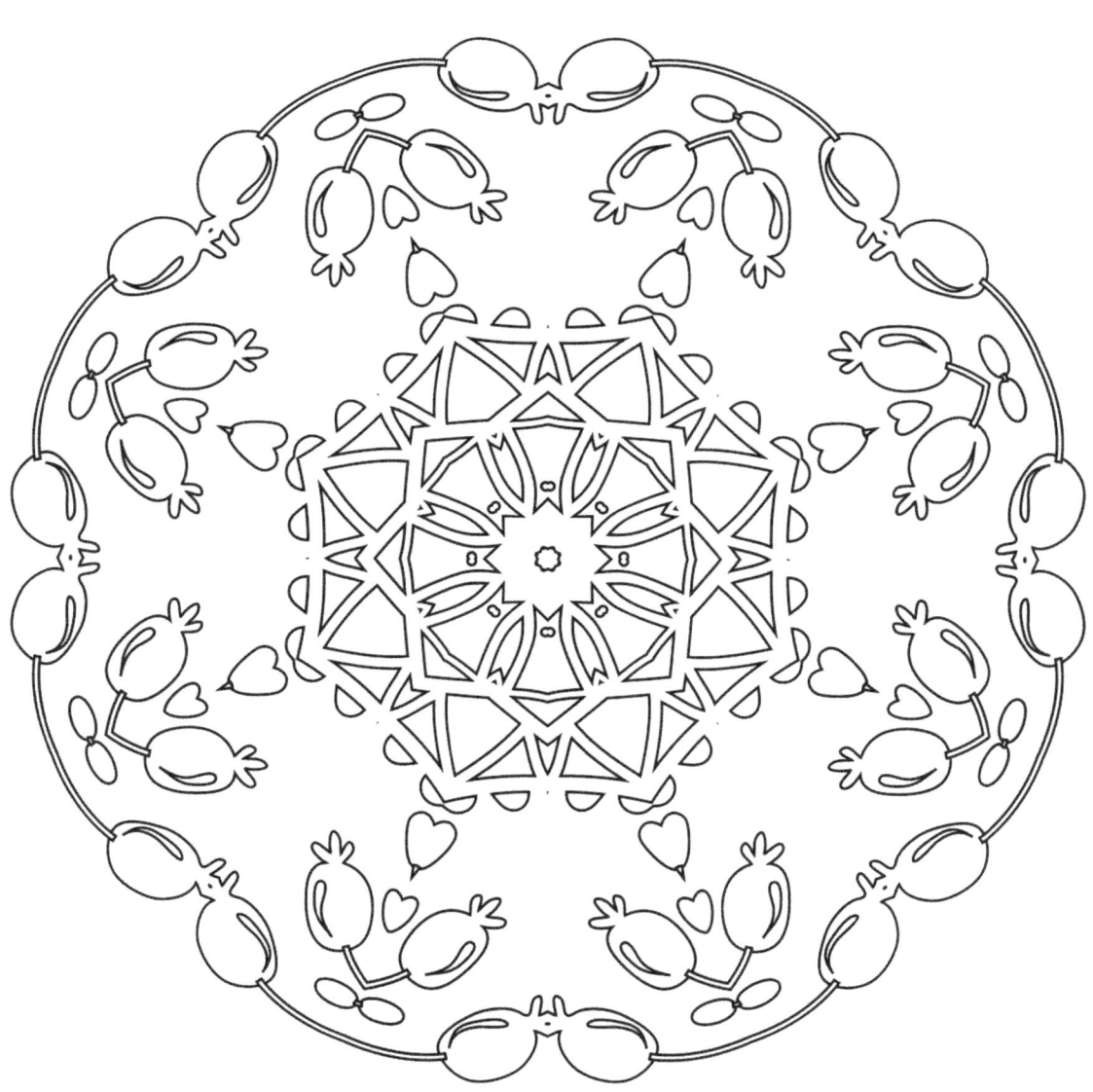

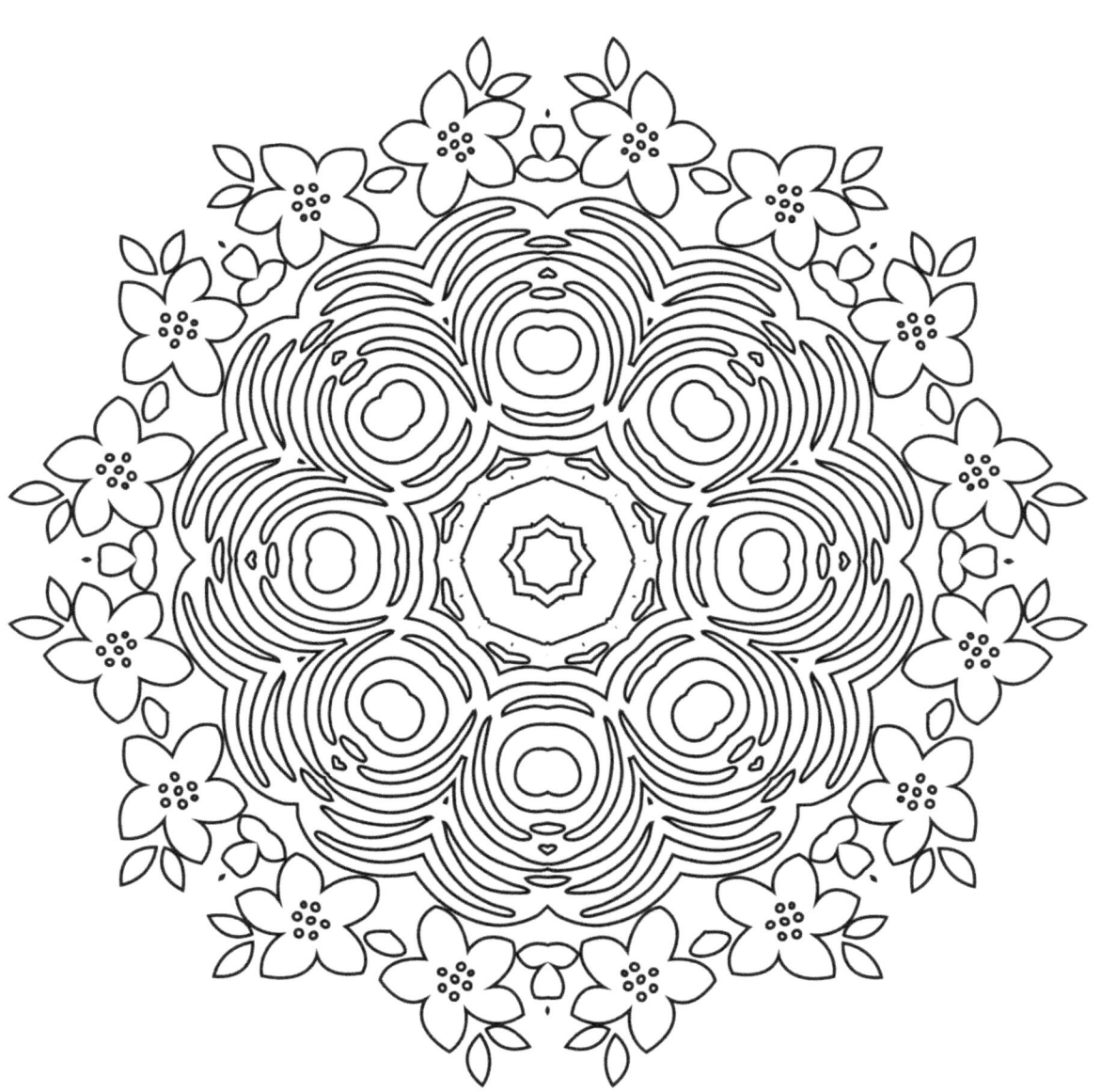

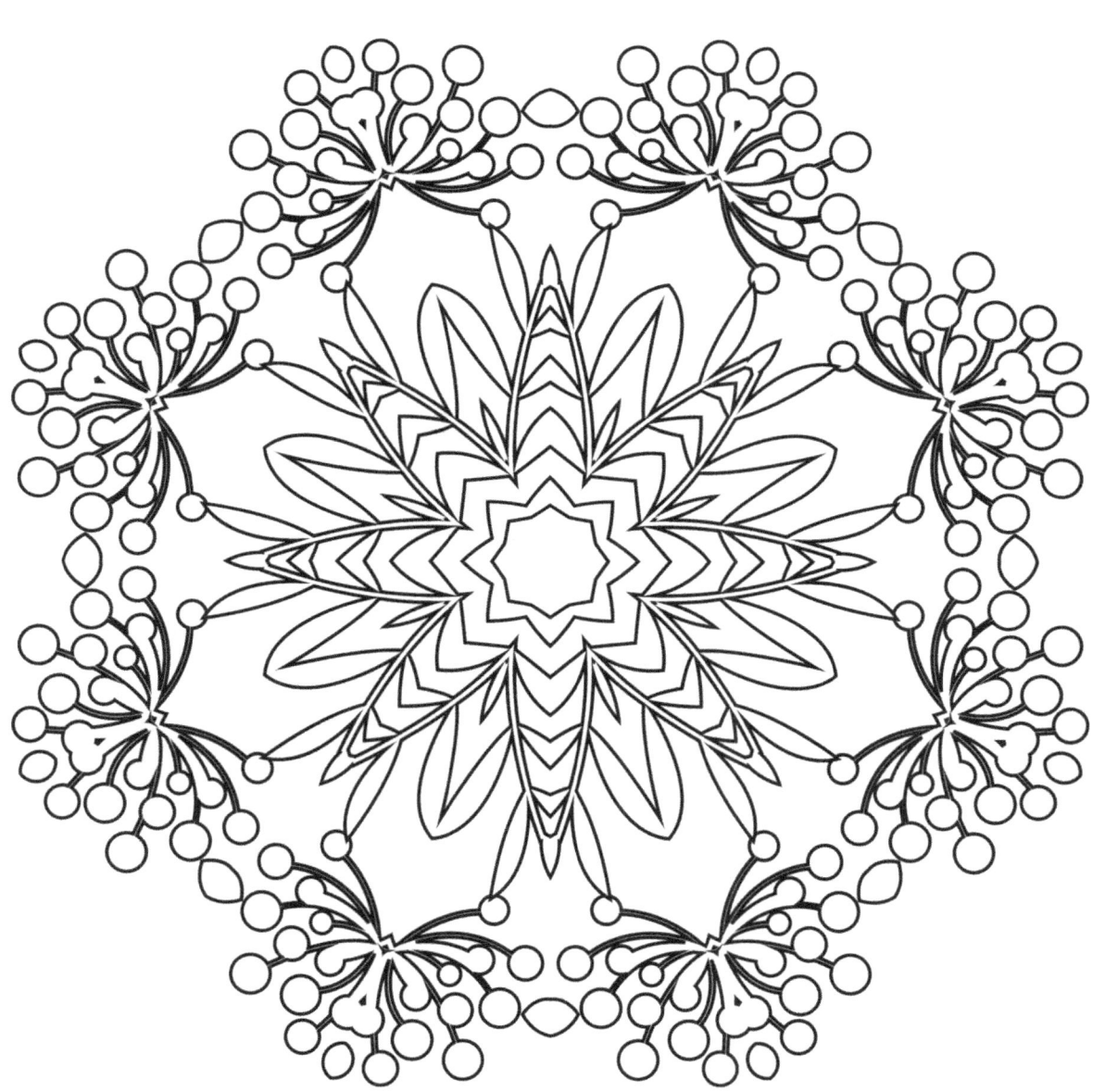

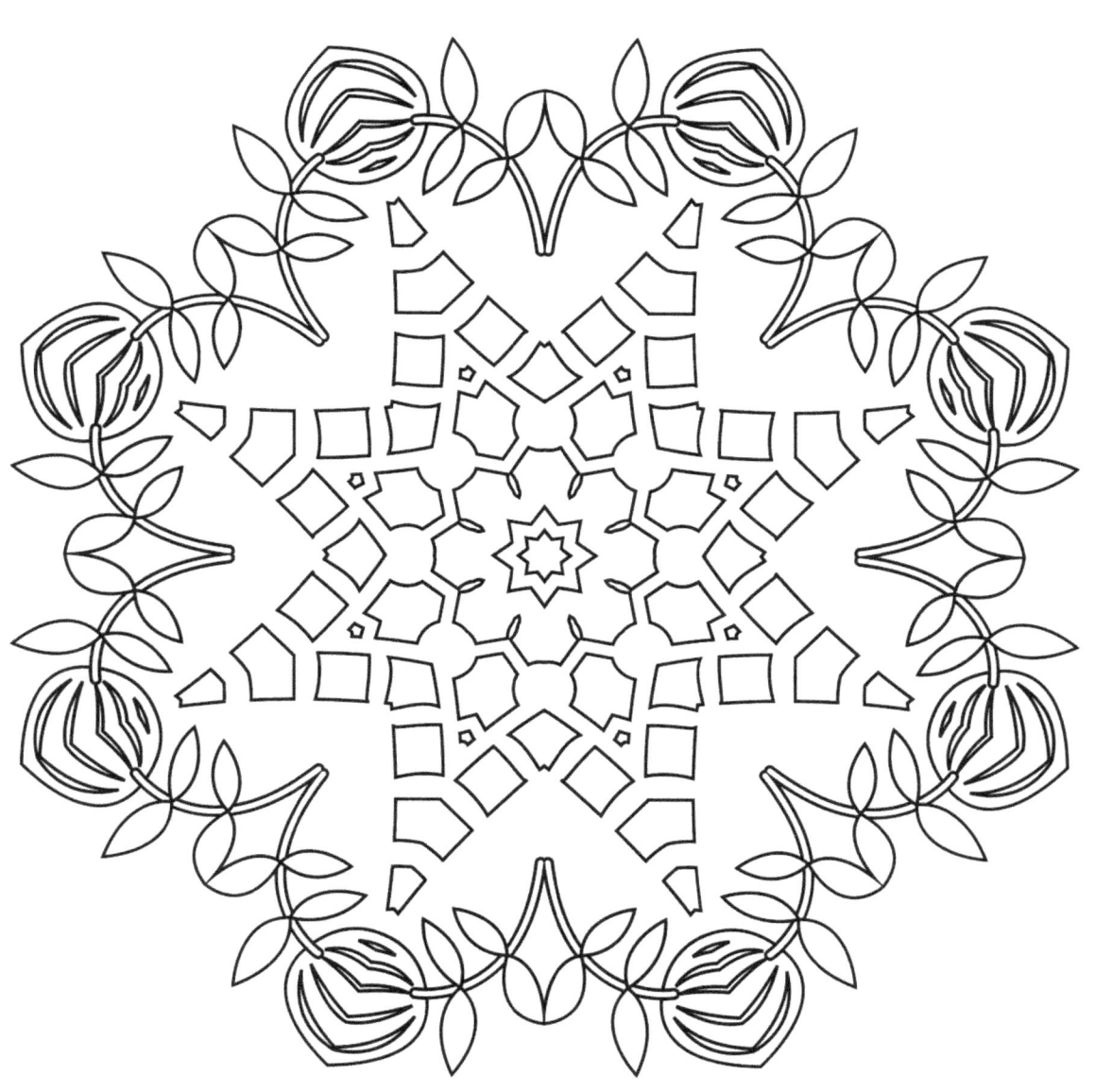

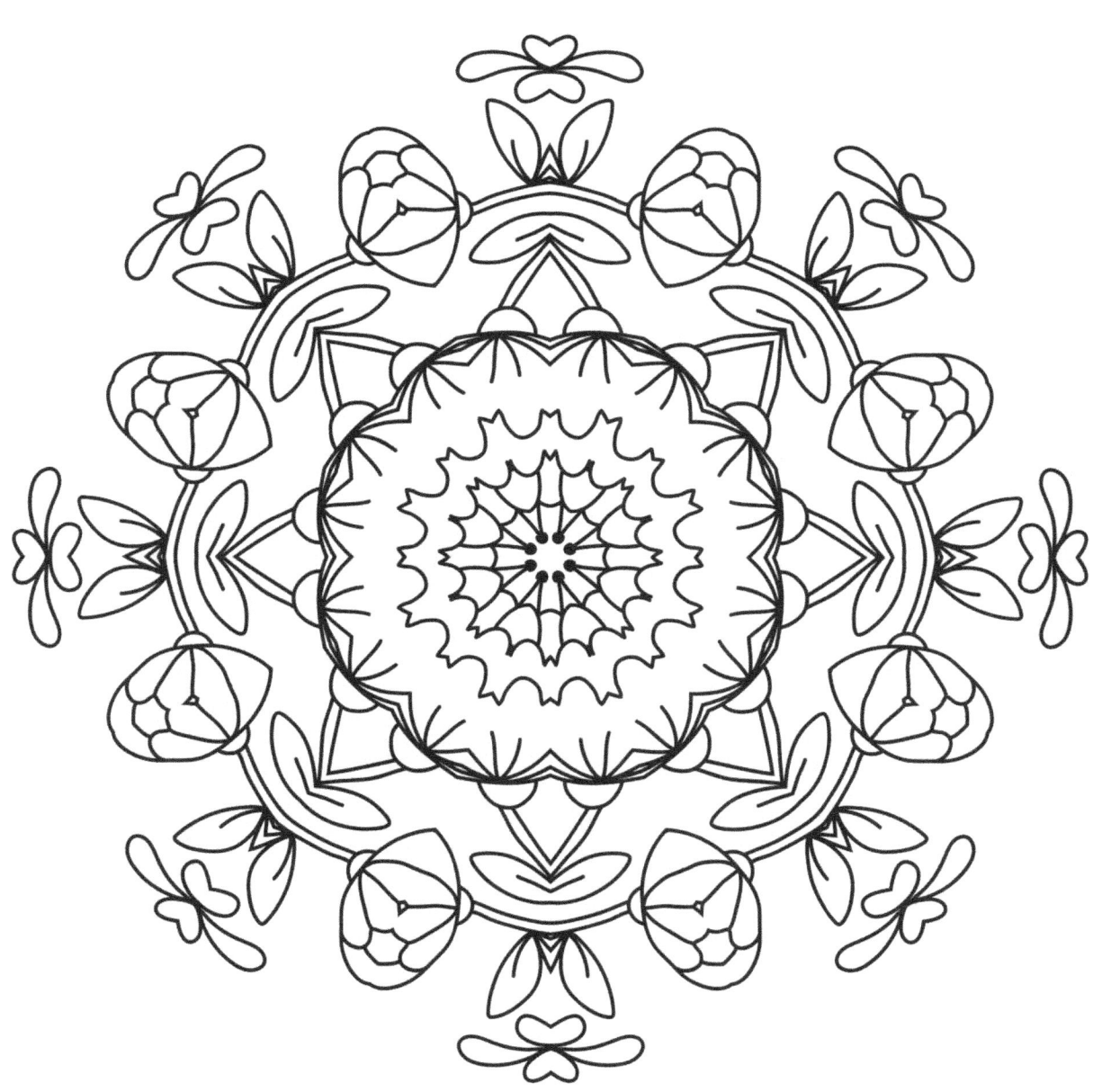

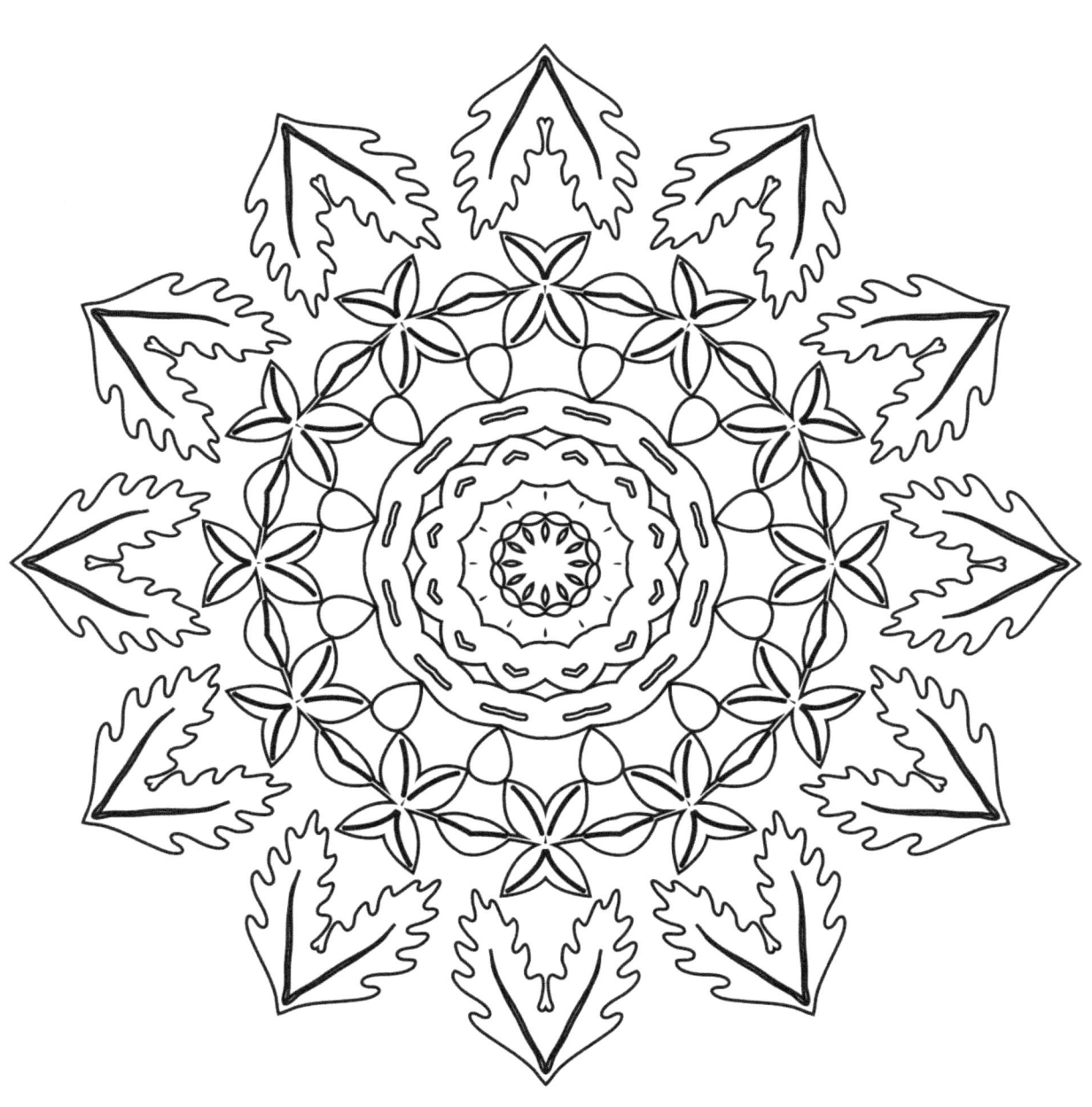

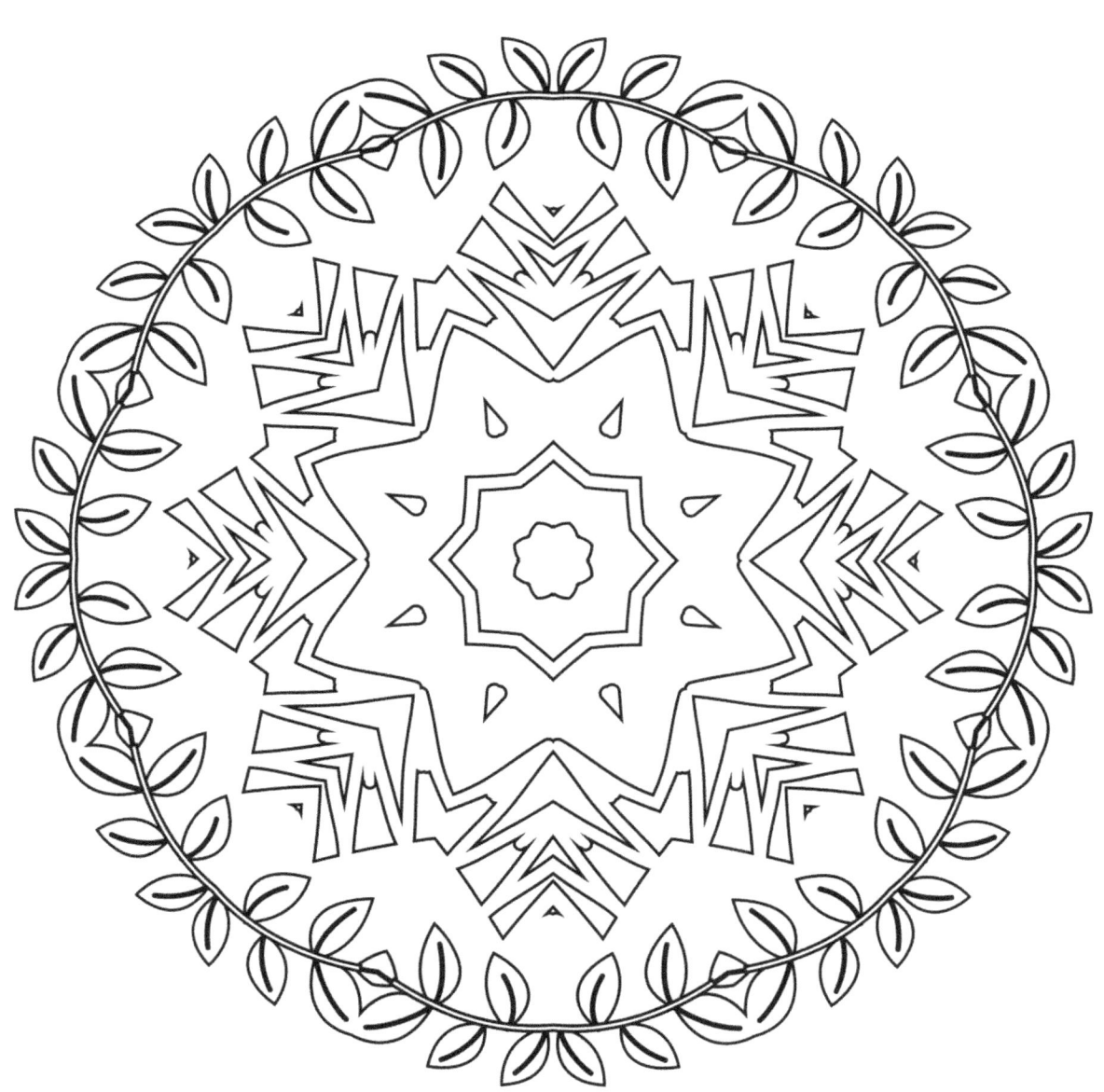

www.ingramcontent.com/pod-product-compliance
Lightning Source LLC
Chambersburg PA
CBHW080553190526
45169CB00007B/2756